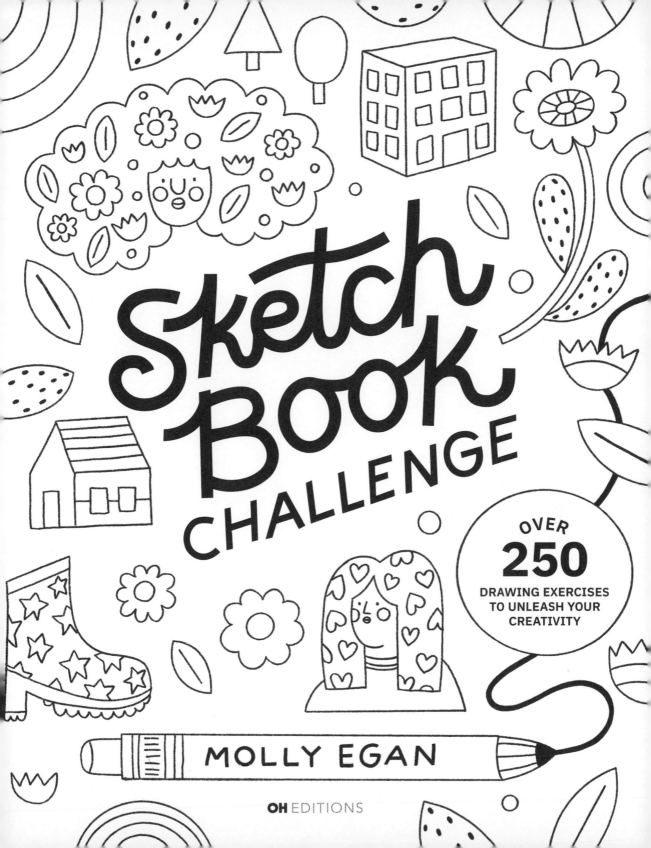

Sketch Book CHALLENGE

OVER **250** DRAWING EXERCISES TO UNLEASH YOUR CREATIVITY

MOLLY EGAN

OH EDITIONS

Contents

Introduction

Welcome!

Drawing and painting can be a daunting thing, even for professional artists. Although it can be a challenge, it is also fun, rewarding and therapeutic. This book will encourage you to create your own sketchbook experiments and find inspiration in everyday things. Exercises will start out fairly guided and get looser as you explore and develop your creative confidence.

I have a lot of coloured pages in this book, because we all know the intimidation of the white page is real! This is actually why I almost always cover the pages of my sketchbooks in paint. Colour adds warmth and happiness, and takes away a bit of the "did I do this right?" fear.

I hope this book helps to guide you on your own journey, encourages you to experiment, and unleashes your creativity. If you'd like, please share your creations under the hashtag **#SketchbookChallengebook**.

Why I Love Sketchbooks

When I was a recent art school grad, I took a day job in an office to make ends meet while I dreamed of becoming a freelance illustrator. While in college, I primarily worked digitally, but all of the screen time at my job made me yearn to be off of a computer when I returned home to make art.

Sketchbooks became that place for me. They were an escape. A place to experiment, to learn, and to find the style I wanted to use as a professional illustrator. Slowly, I gained more confidence with traditional media. I started with paint pens and then evolved to mixing my own colours and using paint and a brush.

My sketchbooks helped me find the work I love to make. They were a perfect way to play, mess up, and try again.

Let Loose

Speaking of messing up, don't be afraid to! Believe me, I've made plenty of bad or ugly drawings. Some of them are even in this book (skip ahead and look at my blind contours on page 42 to see for yourself). Every drawing and exercise is a way to learn and develop, even if the result is not "perfect". Instead, have fun, let yourself loosen up and make mistakes. If worse comes to worse, cover the thing you hate with a piece of paper or dark paint and start over!

How to Use this Book

Warm Up

Warming up isn't only for athletes. Just like you would stretch before a big game or a jog around the block, you should warm up your hand and brain before beginning to make art.

Doing small sketches or paintings before starting my client work has become integral to my process. It warms up my hand, wrist and shoulder, in addition to getting my brain into illustration mode.

In this section, you'll find a variety of activities, from colouring to figure drawing to pattern making. They will not only warm up your muscles but will serve as creative building blocks for the following chapters of exercises.

I suggest spending at least 5–10 minutes warming up. You don't need to necessarily finish an exercise before moving on but complete enough that you get any wonky lines or tightness out.

When you are finished with your Warm Up, choose an exercise from the Weekday or Weekend chapter.

Weekday

Weekday exercises are perfect for making art with limited time. In this chapter, you will be guided with drawings in progress and will use your own creative problem solving to finish them.

They will be fun but slightly more challenging than the Warm Up chapter. The Weekday exercises will continue to build your artistic voice, style and problem-solving skills.

Weekend

The Weekend chapter is designed for open-ended, in-depth creative exploration. In this chapter, there will be instructions in addition to many prompts designed to spark ideas for drawing at home and on the go.

If you have more time and creative energy to spend, I suggest doing a Weekend activity after your Warm Up. I also encourage you to use this book as a space to plan your Weekend exercises, and then move to a sketchbook or watercolour paper to have more freedom with media.

Art Kit

I'm a firm believer that there are no right or wrong materials. Just because something is more expensive doesn't automatically mean that it will be better or that you will like it more. I use a mixture of both high- and low-end materials. I prioritise investing in the media I love and use the most, like paint.

There are a lot of suggestions about particular brands here that work for me, but please, don't get discouraged if they don't end up working for you. I suggest buying one or two colours of the supplies that interest you before investing a lot of money into full sets. It might take some trial and error, but you'll find what you enjoy using.

Use this book as a chance to try out materials that you may not have experimented with before. Not every medium will work on the pages of this book, but you can always take the prompts and explore them elsewhere.

Paint

Holbein Acryla Gouache is my favourite paint. I love its vibrant, opaque colour and its matte finish. It has components of acrylic (does not reconstitute) and gouache (matte and opaque), which is a perfect combination for how I like to work. The matte finish also easily allows you to go on top of the painting with coloured pencils or other media.

This paint is definitely an investment. If you are interested, I suggest picking up one or two tubes in your favourite colours to see if you like it before investing in a lot of paints.

In this book, any matte acrylic or acrylic gouache will do. Make sure you do not use paint with a sheen in your sketchbook. Shiny acrylic paints can make your sketchbook pages stick together, especially when it's humid. In addition to my pricier paints, I also buy inexpensive matte paints at craft stores.

Paint Brushes

I have used both cheap and expensive brushes. The premium brushes work wonderfully, but I've realised that I can't be trusted to properly care for them. Now I typically stick to budget, student-grade brushes.

I typically paint with round brushes. They are the most comfortable for me, since I mostly paint rounded shapes. There are many different brush shapes, so I suggest trying them out and seeing what is most comfortable for you.

Paint Pens

Paint pens are what got me back into painting after several years of making mostly digital work. Even though you feel like you are drawing, you produce a painted result! I personally think that's pretty cool. They are also perfect for on-the-go drawing. My favourite brand is made by POSCA.

Coloured Pencils

There are so many coloured pencils out there, and they really vary in quality. My favourite brands are Prismacolor and Derwent. They have vibrant colours and aren't super waxy. Some coloured pencils, especially student-grade ones, can have a lot of wax. Waxier coloured pencils are harder to use over paint and can also be difficult to blend together.

Pencils

I don't use any fancy pencils. Actually, I still use the same Bic mechanical pencils I used in high school math class to make my drawings today. I also firmly believe you can never go wrong with a Dixon Ticonderoga.

Gel Pens

I was born in the early 90s, so of course, I love a gel pen. My favourite brand is Gelly Roll. They have many different colours, and all of them are opaque. They are another great option for on-the-go sketchbooking.

Scrap Paper

Scrap paper has loads of uses in sketchbooks. You can use coloured paper to make collages, to cover drawings you aren't fond of, or to use as backgrounds for your drawings.

I also always put a piece of scrap paper in front and behind the page I'm drawing/painting on. It prevents any transfer of pencil or paint from your current spread or previous spreads.

Clips

Clips are helpful when you are working on or photographing a page. If you have bulldog clips, those work great, but if you only have bobby pins or hair grips in your house, they do the trick too!

Sketchbooks

Moleskines are my go-to sketchbook. They happily accept acryla gouache and most other media. I typically have one of their small and large art sketchbooks going at the same time. They also have sketchbooks specfically created for watercolours.

Test Pages

Use these pages to test out different media that you have to see how it works in the book.

Warm Up

Give these people some new hairdos.

Add windows and doors to these houses.

Colour in the faces.

Add patterns to their clothes.

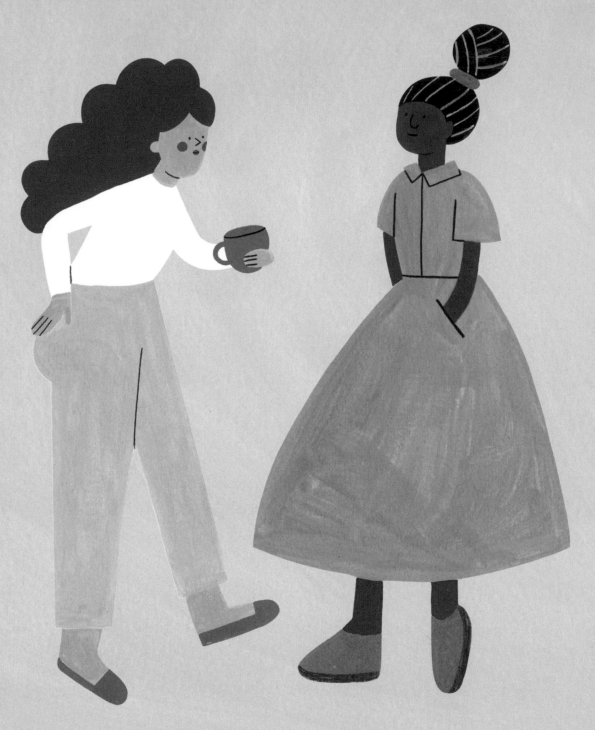

Add designs to each part of the tea set.

Draw in a face for each of these people.

Colour in the houses.

Decorate the rooms with your own patterns.

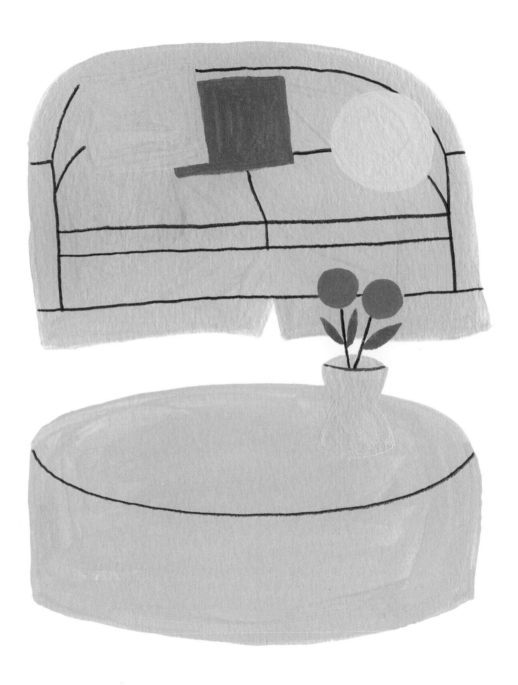

Colour the animals.

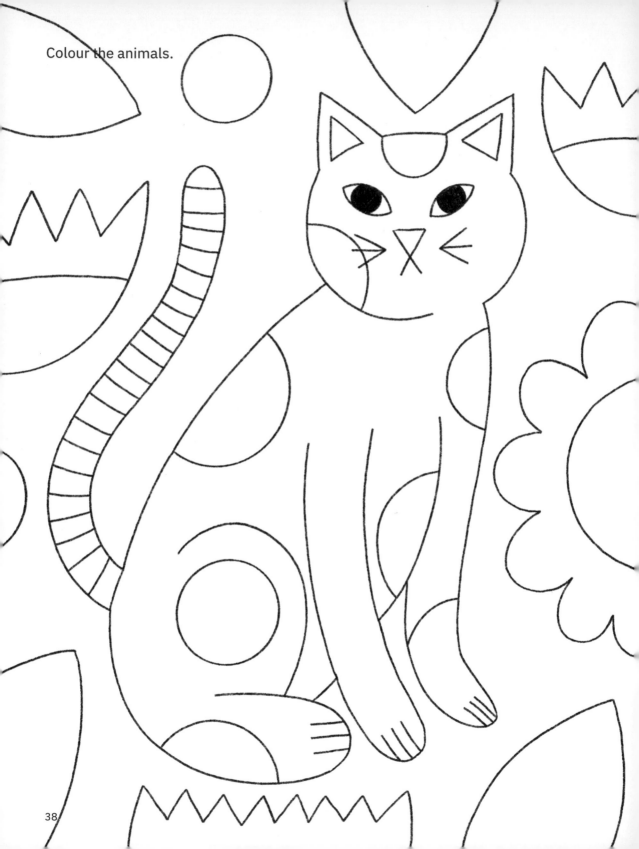

Add a manicure, jewellery and/or tattoos to the hands.

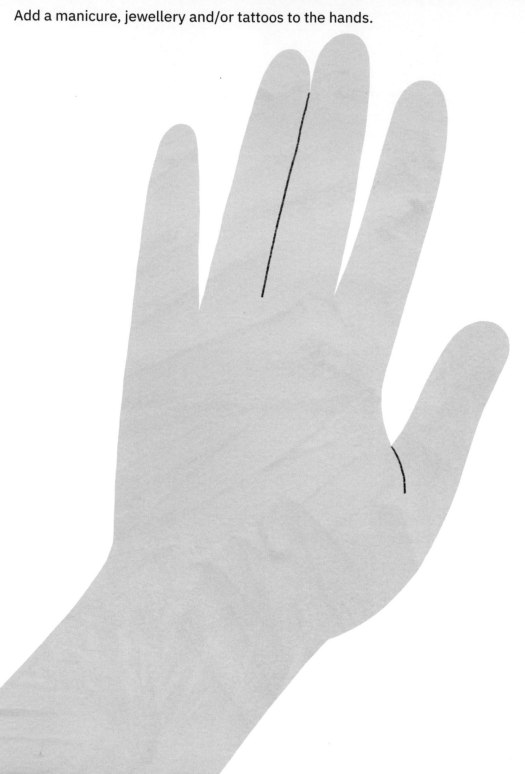

Blind Contour

Blind contours are great for improving hand—eye coordination, warming up and also, they really make me laugh! When making a blind contour drawing, you do not look down at the page or lift your pencil. Instead, you really focus on looking at the subject you are drawing. These are a completely no pressure exercise, so resist the urge to look. They aren't meant to be perfect!

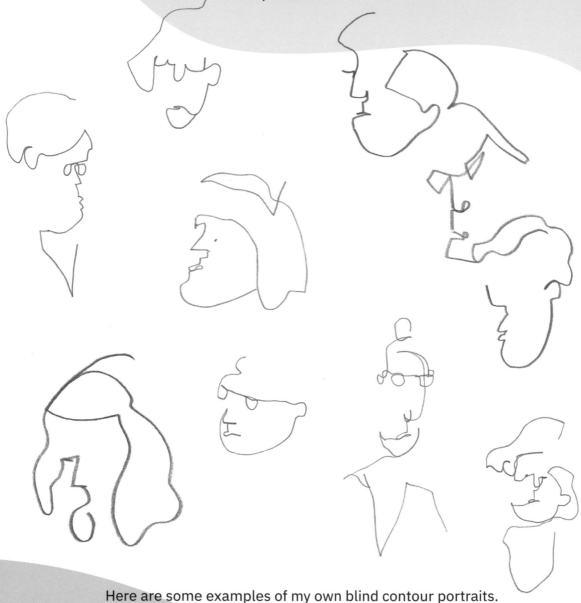

Here are some examples of my own blind contour portraits.
Create some of your own! on the facing page.

Add some welcoming colour to these front doors.

These are inspired by some of my favourite doors in Philadelphia (where I live)!

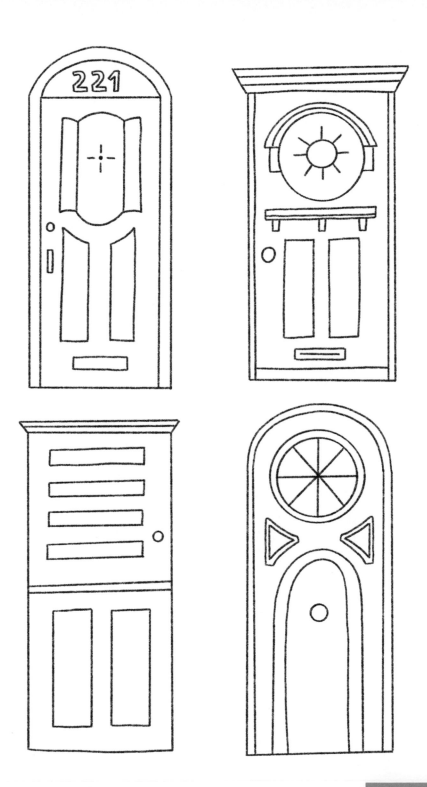

Make these tote bags your own.

Add cute doodles to these undies.

Colour in the flowers with as many materials as possible. Don't forget the background!

Add your own patterns and designs to these articles of clothing.

Draw in faces for these people.

Finish the flowers by adding stems, leaves or blooms.

Draw a shape with every coloured pencil you own.

Fill the squares with your own pattern designs.

Pattern ideas: Shapes (triangles, squares, circles, hexagons, trapezoids, rainbows)
Plants (flowers, trees, leaves, branches, fruits, vegetables, cacti)
Animals (dogs, cats, pigs, raccoons, birds, lizards, pandas, foxes)
Insects (butterflies, bees, caterpillars, spiders, dragonflies, moths)

Need some colour palette ideas? Go to page 228 in the Weekend section.

Make these coffee and tea cups fun!

Colour the lady and give her jewellery and hair.

Colour the pattern.

Add pattern to the chairs.

Fill these window boxes with lively, happy plants.

Let's do some more blind contour drawings! This time, fill this page with blind contours of your hands. If you need a reminder of what a blind contour is, flip back to page 42.

On this page, do a blind contour portrait of yourself or someone else.

Design plates for a fancy dinner.

Give the curtains a pattern. Feel free to design some wallpaper and a scene in the window too!

Plant something in this planter.

Add some patterns to these clothes.

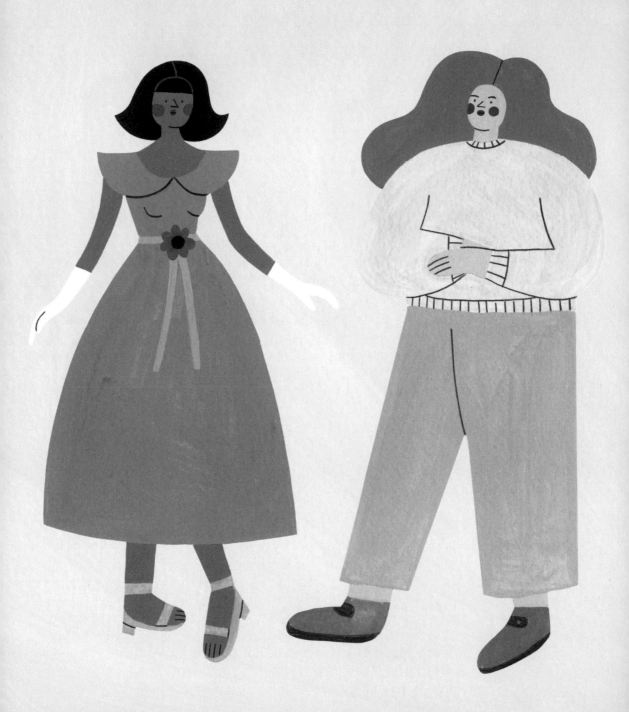

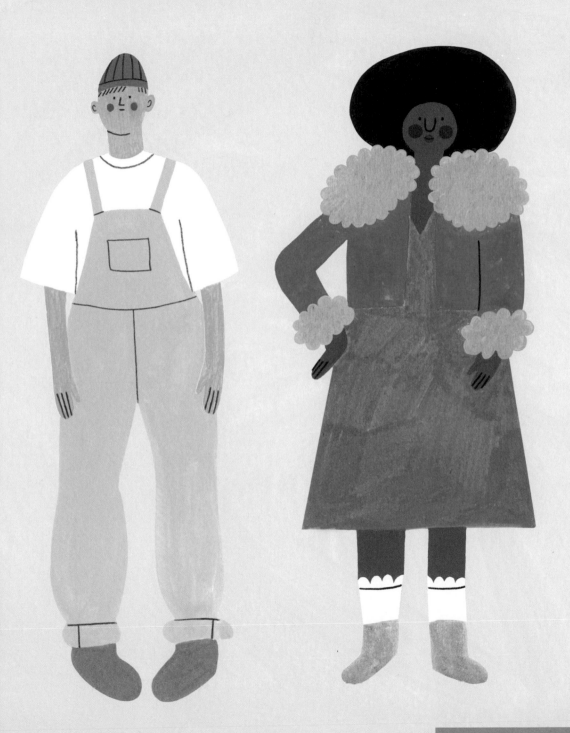

Add colour and pattern to this winter gear.

Fill these pages with your own warm-up doodles!

Colour these drawings.

Drawing with Both Hands

Drawing with both hands at the same time is another fun exercise to warm you up. It's challenging, and really makes your brain go into overdrive! Try doing a drawing that is a mirror (or reflection of each other). You'll find that curves are especially difficult to do with your non-dominant hand!

Here is my example of a two handed, reflection drawing.
On the next page, try making your own!

Now, do some drawings completely with your non-dominant hand. It's challenging, but makes you *really* look at your subject and concentrate on your drawing!

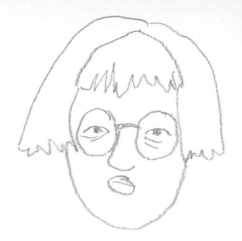

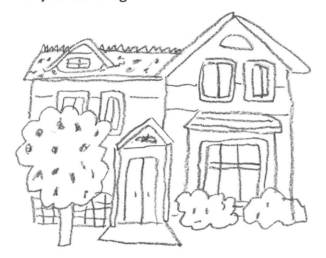

Cover the refrigerator in magnets.

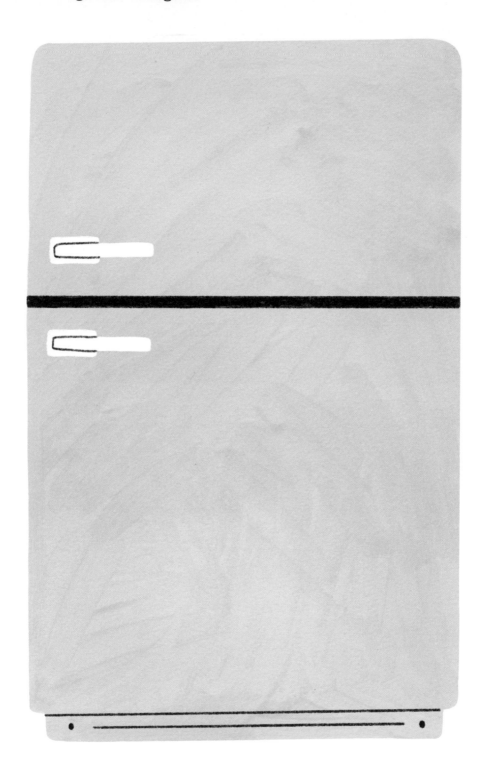

Give these pots some plant friends.

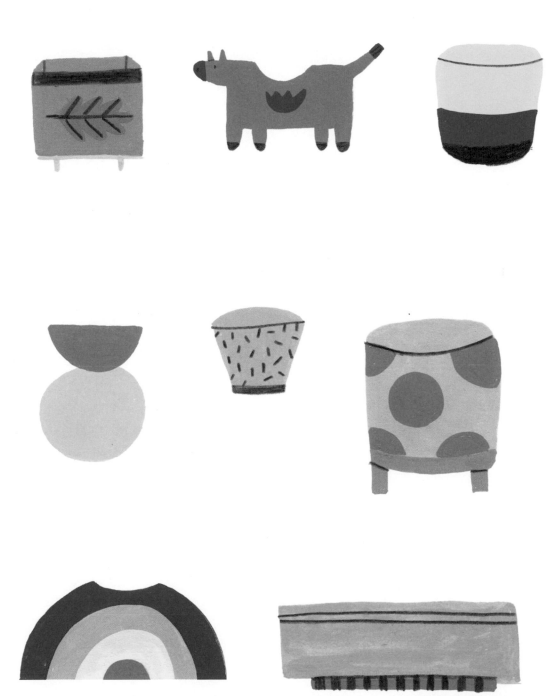

Add designs to the birds.

Doodle on the butterflies.

Design the cake. Is it for a wedding, birthday or something else?

Add gift wrap and bows to these presents.

Add flair to the front and back of this denim jacket.

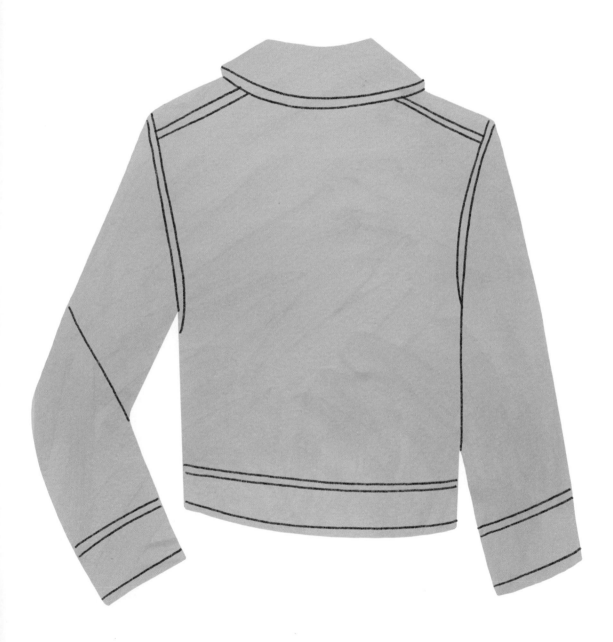

Turn the rectangles into patchwork quilts.

Add patterns to the bedding.

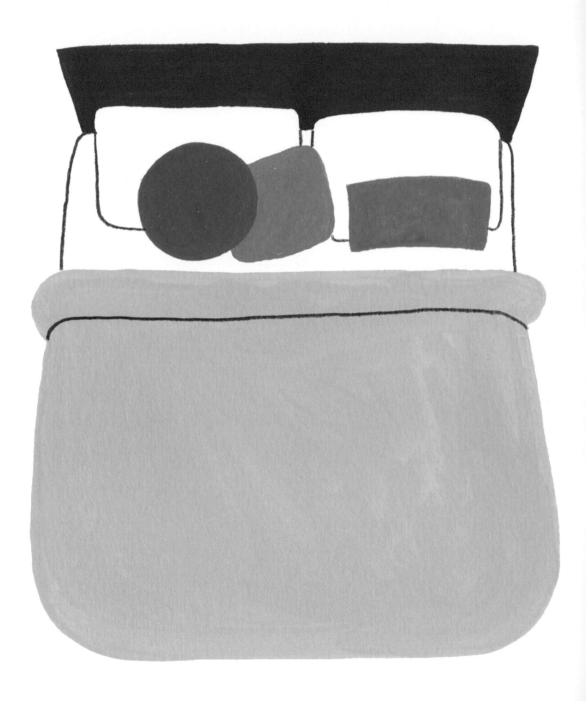

Design the shoes.

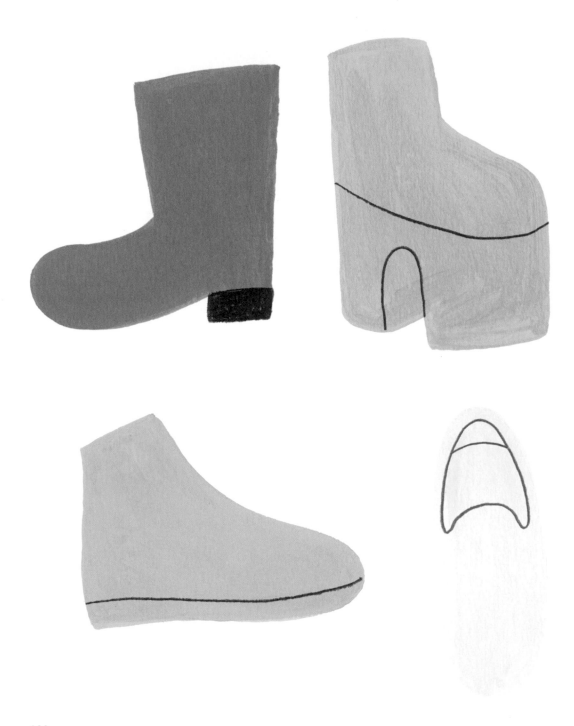

Colour and design the clothes.

Fill this spread with blind contours (see page 42 for a reminder) of plants.

Design the umbrella. Don't forget a rainy background!

Colour the pattern.

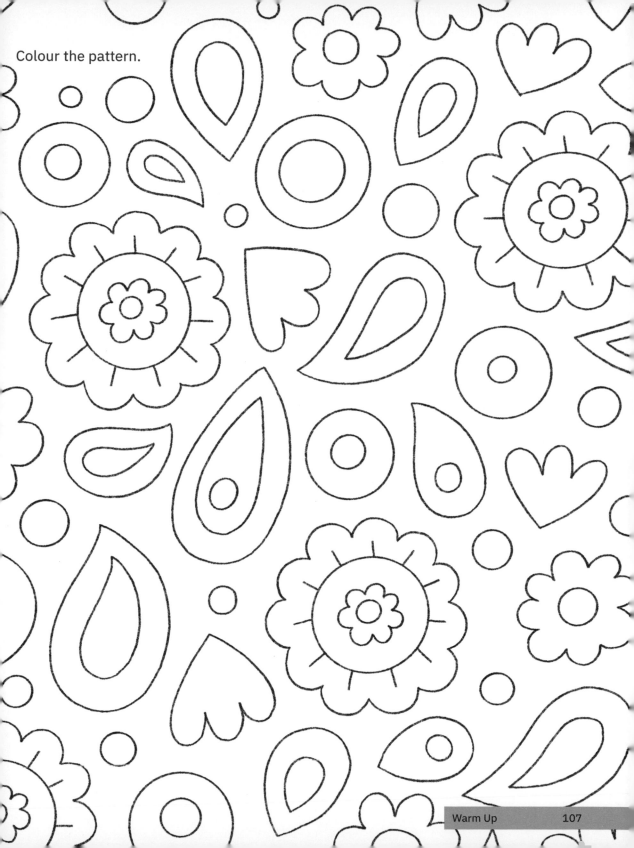

Add floral arrangements to the vases.

Add windows and doors to the apartment building and house.

Weekday

Finish these lamps by adding a shade or base.

Add wings to the butterfly.

Fill the gallery wall with art. You can also colour the picture frames.

Put furniture and decor in the room.

Design the envelopes by adding colour, pattern, addresses and your own stamp ideas.

Create your own greeting card collection.

Add buildings, trees, cars and whatever else you'd like to this winding road.

Turn this green space into a park. You can add a playground, people picnicking and more!

Add knick-knacks to these shelves.

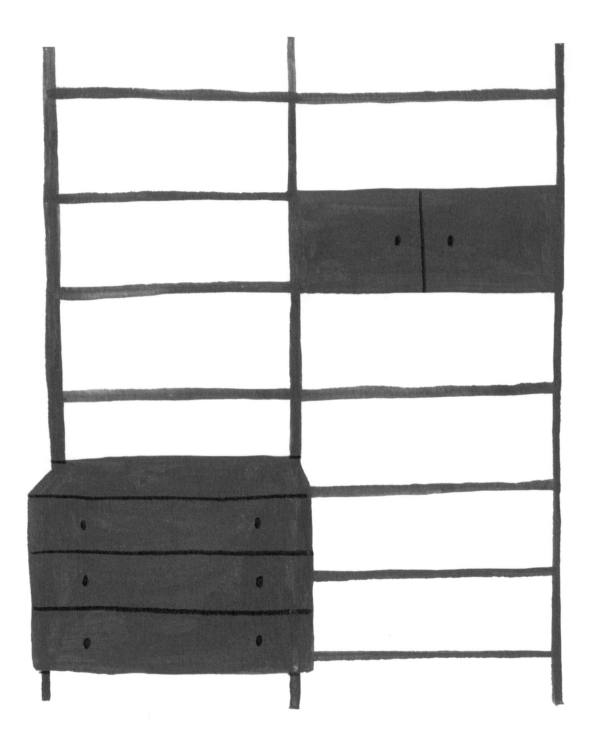

Put pictures in the frames.

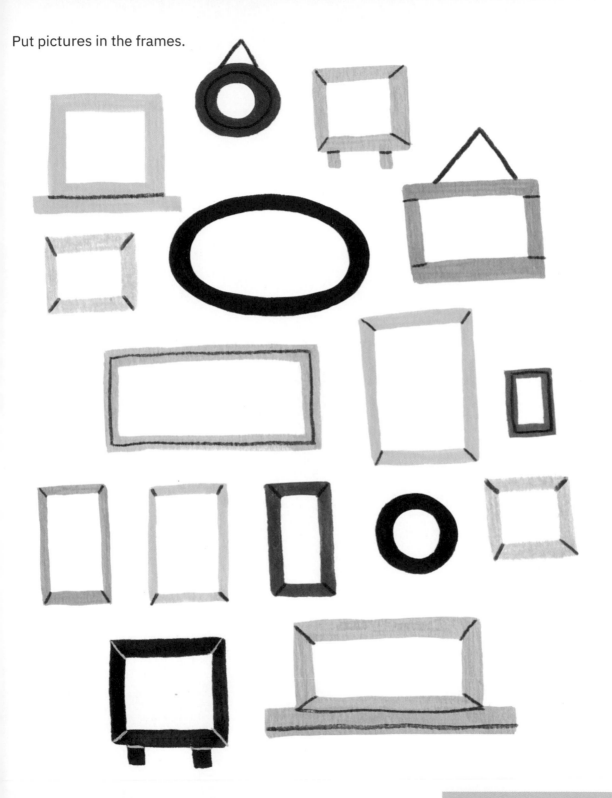

Design this mantlepiece.

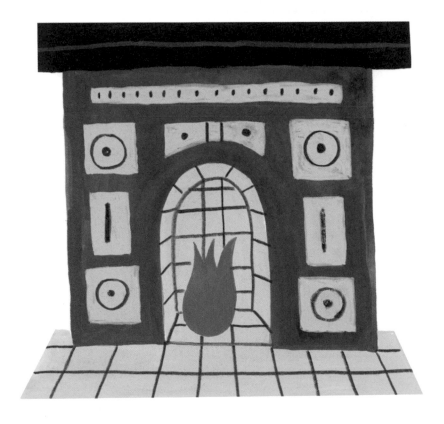

Add candlesticks to these candles.

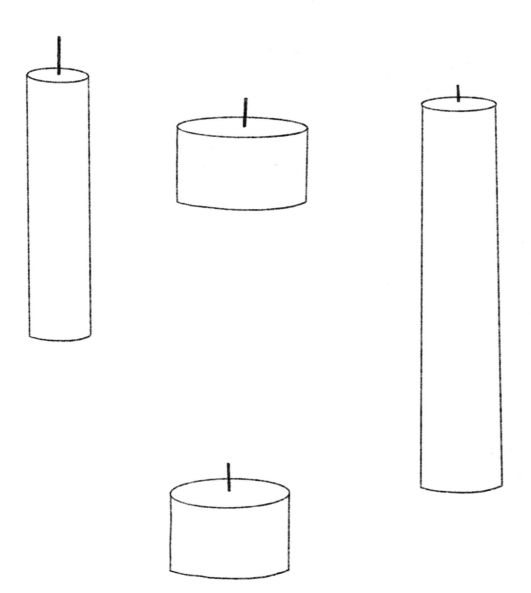

Add faces to the hairdos.

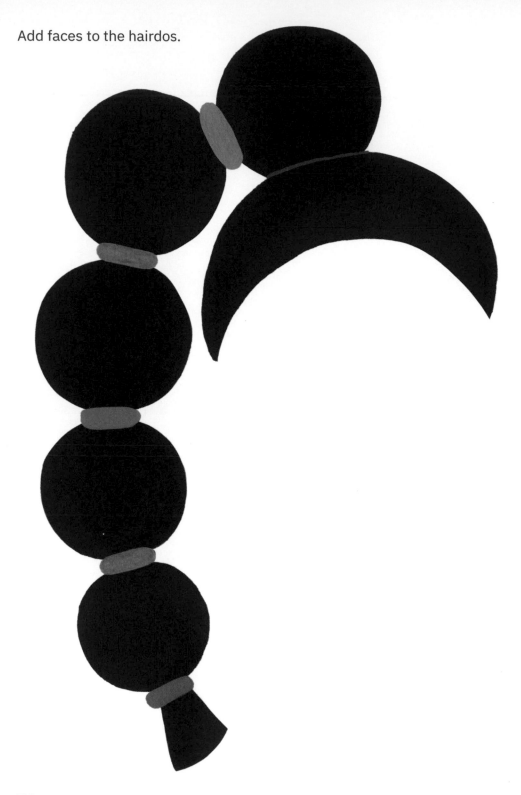

Finish this table setting.

Create frames for these pictures.

Add tourists to the beach scene.

Complete the people.

Do two 10-minute figure drawings on this page.

Do one 20-minute figure drawing on this page.

Turn these blobs into things!

In college, my friends Abayomi, Rebecca and I would take turns drawing a blob and having someone else turn the blob into something. Use this space to collaborate with a friend, roommate or partner on blobs!

Reimagine a classic book cover.

Create a book cover for your autobiography.

Add colour, lettering and decoration to these cakes. The message can be sweet...
or sassy!

Finish the bathroom scene.

Complete the bird.

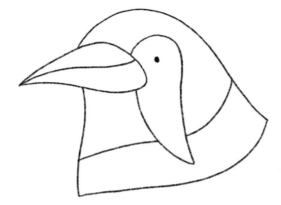

Add bugs to the forest floor.

Complete the pattern.

Fill in the speech bubbles with phrases or words.

Finish both geometric patterns.

Put shows on the televisions.

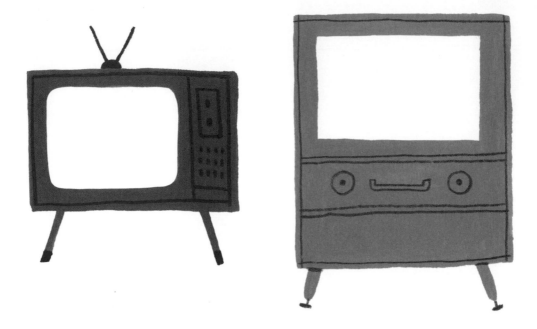

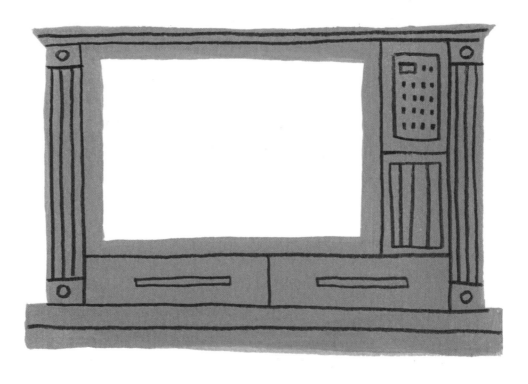

Create your own album covers.

Fill the meadow with plants and animals.

Add sealife to the ocean.

Fill in this landscape with houses, people, cars, trees, flowers, etc.

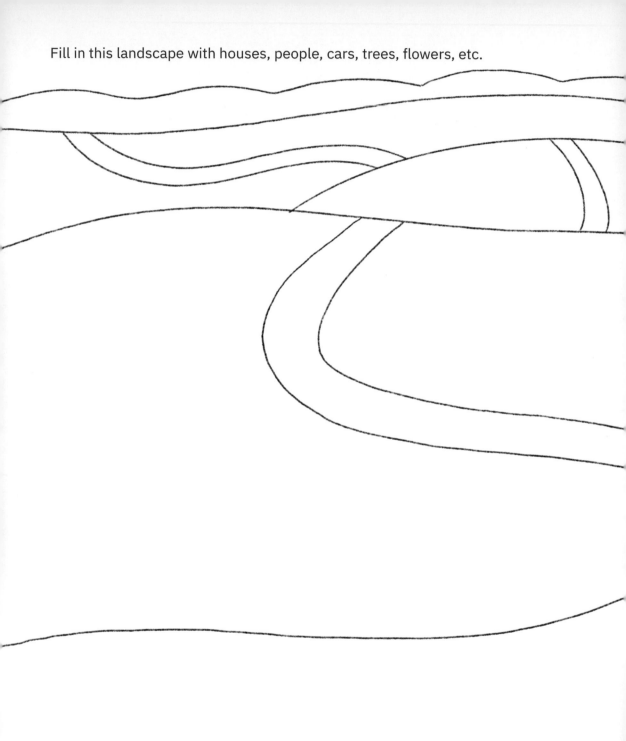

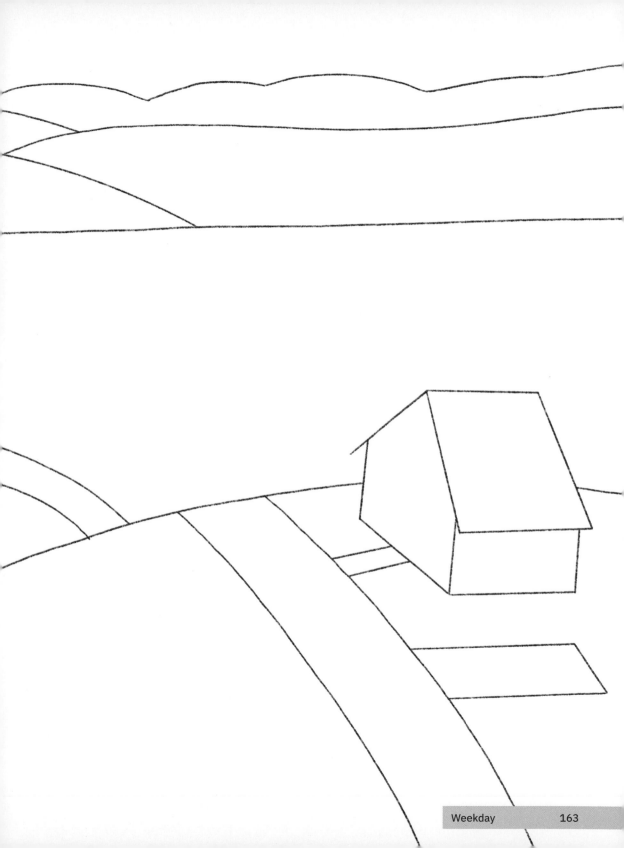

Make two patterns with these shapes.

Add people to these outfits.

Draw owners for these animals.

Finish the kitchen. Maybe add hardware to the cabinets and a big farmer's sink?

Design outfits for these people.

Add plants in the garden.

Finish the living room! You can add a coffee table, armchair, bookshelves, etc. as well as pattern and colour to the couch and rug.

Add life and decoration to the city block.

Complete the rest of the animals.

Put the people in costumes. Don't forget to add a fun wig!

Draw owners for these animals.

Add give outfits (and a face) to the people.

Put people in the outfits.

Draw people enjoying a party.

Complete the people.

Fill the trail with bikers and runners.

Add shapes, flowers or other designs on the creatures.

Complete the town by adding colour and features to the buildings.

Give outfits (and a face) to the people.

Turn this space into a cafe.

Complete the bedroom. Maybe add some plants, shelves and a bed?

Add people and floaties to this pool party.

Put a meal on these plates.

Finish these people.

Finish this cityscape.

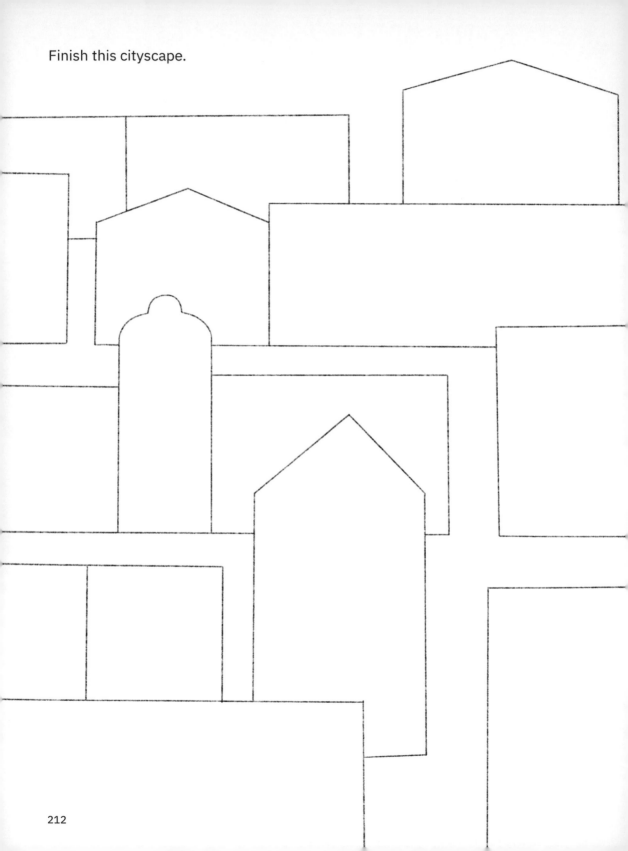

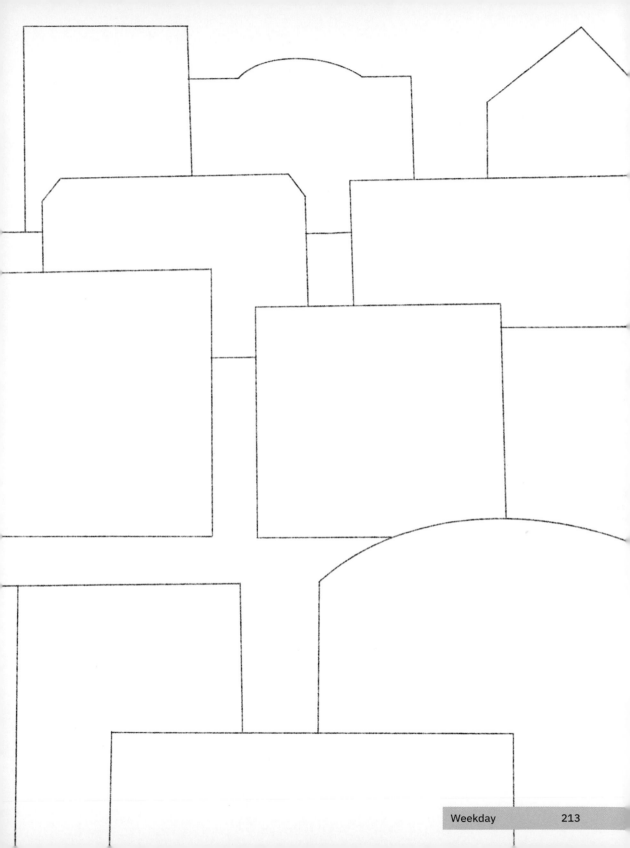

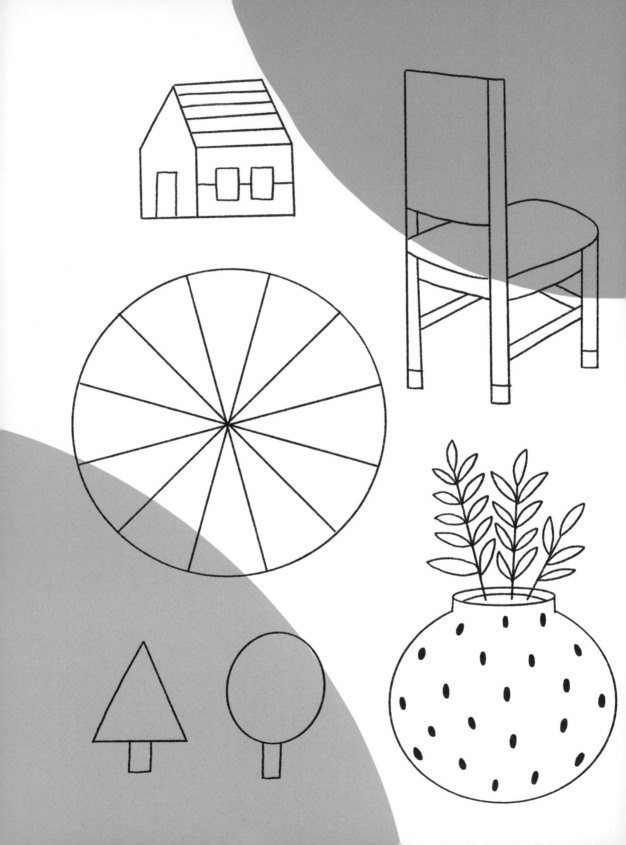

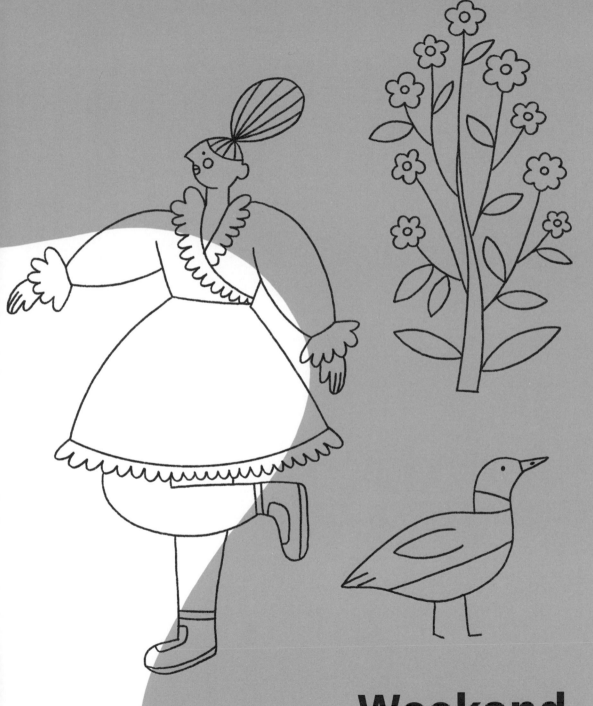

Weekend

Your Fun Things to Draw List

We *all* have moments where we get stuck and uninspired. Sometimes, it really is good to give yourself a break, and other times it's helpful to push through. Try making a list of 100 things you like to draw. It will be great to come back to reference on a day with creative block!

1. _____
2. _____
3. _____
4. _____
5. _____
6. _____
7. _____
8. _____
9. _____
10. _____
11. _____
12. _____
13. _____
14. _____
15. _____
16. _____
17. _____
18. _____
19. _____
20. _____
21. _____
22. _____

23. _____
24. _____
25. _____
26. _____
27. _____
28. _____
29. _____
30. _____
31. _____
32. _____
33. _____
34. _____
35. _____
36. _____
37. _____
38. _____
39. _____
40. _____
41. _____
42. _____
43. _____
44. _____

44. _____
45. _____
46. _____
47. _____
48. _____
49. _____
50. _____
51. _____
52. _____
53. _____
54. _____
55. _____
56. _____
57. _____
58. _____
59. _____
60. _____
61. _____
62. _____
63. _____
64. _____
65. _____
66. _____
67. _____
68. _____
69. _____
70. _____
71. _____
72. _____

73. _____
74. _____
75. _____
76. _____
77. _____
78. _____
79. _____
80. _____
81. _____
82. _____
83. _____
84. _____
85. _____
86. _____
87. _____
88. _____
89. _____
90. _____
91. _____
92. _____
93. _____
94. _____
95. _____
96. _____
97. _____
98. _____
99. _____
100. _____

Combine #40 and #87 from your Fun Things to Draw List on the previous pages into one illustration.

Make an illustration from item #5 on your Fun Things to Draw List on the previous pages.

Make a drawing that combines items #1, #50 and #99 from your Fun Things to Draw List on page 216.

Pick your own random words from your Fun Things to Draw List on page 216 and combine them.

Drawing in Shape

Drawing figures can be hard and intimidating even with a lot of practice. Instead of trying to draw a perfect face, torso or arm, I think of each part of the figure as a shape. In this example, I saw the figure mostly as trapezoids and rectangles. Though I'm using figures as an example, you can draw anything in shape!

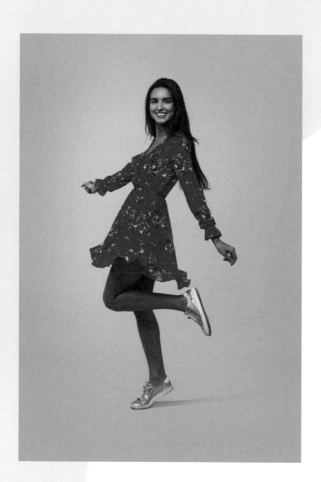

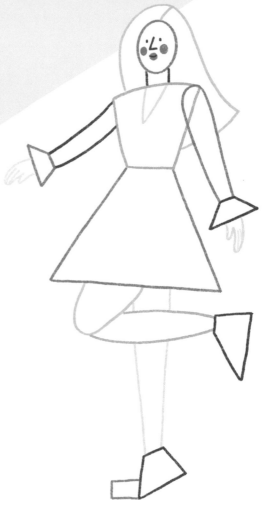

Breaking the figure into shapes can also be a great place to learn how to stylize. You can make the shapes larger, wider, longer, thinner or distort them completely. The decisions you make will build your artistic voice and style.

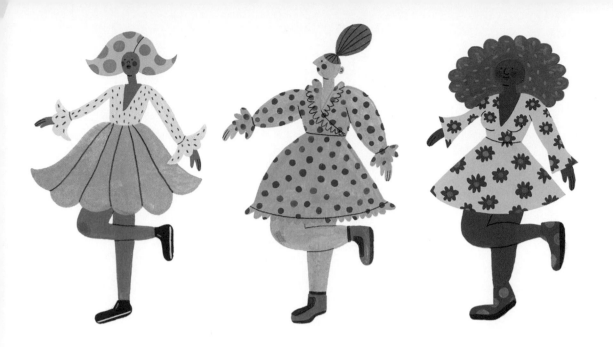

Draw your own versions here.

Find your own reference photo of a full figure, print it out (or rip it from magazine) and draw it on the next page. Remember to try drawing your subject in shape!

Take two! Pick out another reference photo, tape it here, and draw it on the next page. This time, try a portait.

Colour

Creating colour palettes can be tough if you don't know the basics. Learning some fundamental colour theory can really elevate your drawings and paintings. We'll start with some essentials, and then you can dive into making your own palettes.

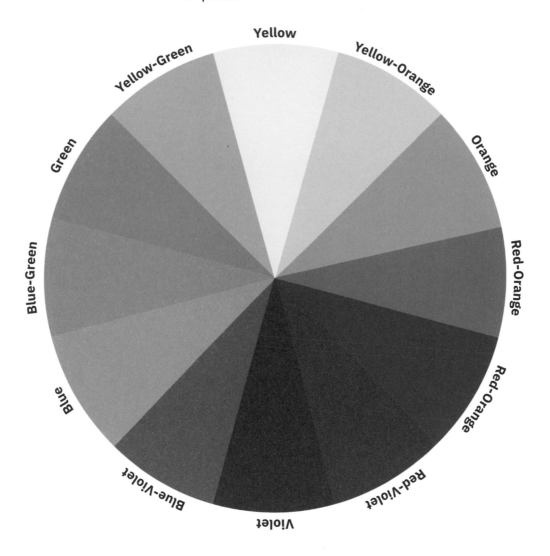

Say hello to the colour wheel! It is a collection of 12 colours. Three **primary** (yellow, red, blue), three **secondary** (orange, violet, green) and six **tertiary** (yellow-orange, red-orange, red-violet, blue-violet, blue-green, and yellow-green). Keep in mind while creating your own palettes, that these colours don't have to stay at their most vibrant, you can also lighten and darken them.

Complementary

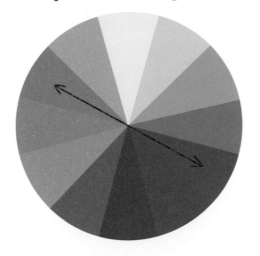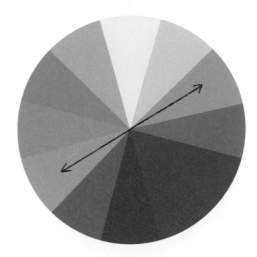

Complementary colours are directly opposite of each other on the colour wheel. I love to use complementary colour schemes in my work. Instead of using them at their most intense, I often darken/lighten the shades of the complementary colours. You can also mix colour opposites together to make vibrant browns.

Split-Complementary

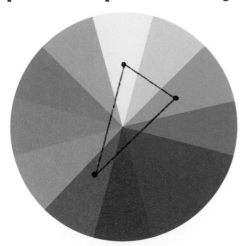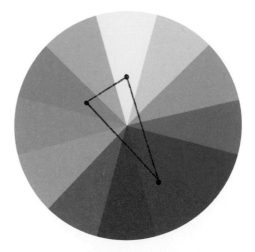

Split-complementary schemes are very similiar to complementary schemes with a little twist. They are made by taking a colour on the wheel, looking directly across to the complement, and then using the colours on either side of that complement.

Analogous

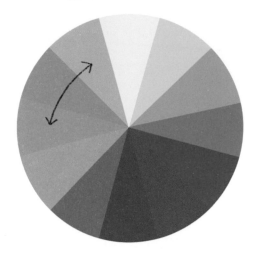 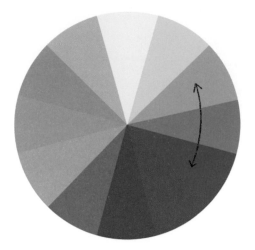

Analogous colour schemes are a great way to build a harmonious palette. They are made by choosing three colours next to each other on the colour wheel.

Triadic

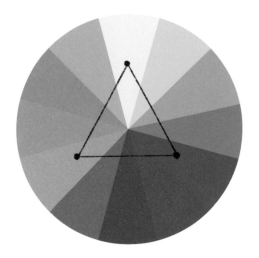 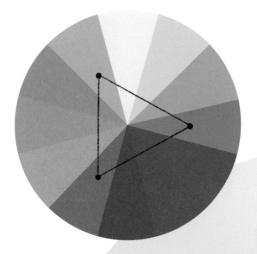

Triadic colour schemes are made by choosing colours that are evenly spread around the colour wheel. Typically, these work best if you let one of the three colours be dominant and the other two as accents.

Use these colourwheels to plan palettes for your next exercises!

Draw an animal using complementary colours.

Draw buildings with an analogous colour scheme (page 230).

Create a butterfly with a triadic palette.

Draw a plant with split-complementary colours.

Draw a portrait with a split-complementary palette.

Set up a still life and draw it using an analogous palette.

Draw a self portrait without looking in a mirror.

Letter your name 10 different ways.

Draw a friend from life.

Draw a portrait of a famous person.

Fill these pages with drawings of hands.

Draw your favourite pair of shoes.

Create your own perfect bouquet of flowers.

Draw a grumpy face.

Draw an excited face.

Draw a sad face.

Draw a sassy face.

Illustrate yourself in your favourite outfit.

Sketch your favourite plant.

Create your own hand-lettered alphabet.

Draw here when you had a great day.

Draw here when you had a bad day.

Drawing on the Go

Drawing on the go is a great challenge and way to energise your drawing process. It can definitely be frustrating to draw people, animals, and things that are moving – but for me, that's also part of the fun.

I draw on location in a few different ways. It's a great time to do some blind contours (page 42) and other less precious drawings that are quick and fun (which you can see on the opposite side). If I'm going for a more finished drawing, I will paint pages in my sketchbook and then draw on top with Posca paint pens, gel pens and coloured pencils. This results in a more finished-looking drawing.

On the next few pages, you'll see some suggestions of where to draw on location, examples of drawings I have done, and plenty of room to do your own drawings!

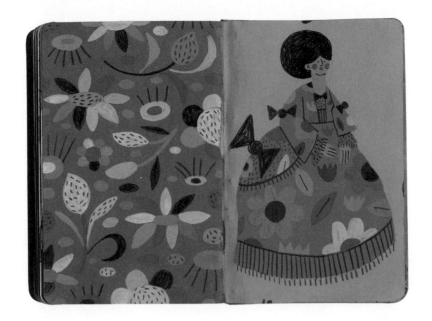

I did an online tour of the V&A Museum in London and The Frick Collection in NYC during the pandemic. I picked out a few things I was inspired by and created this pattern and dress.

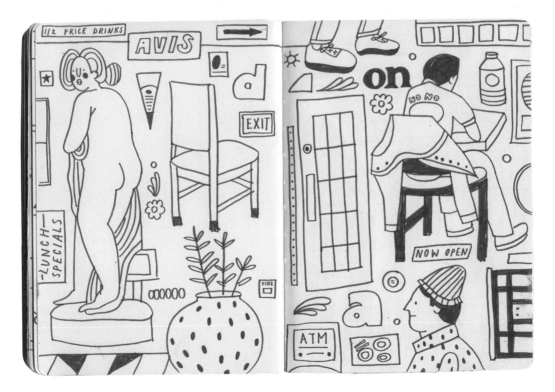

I drew this spread while on a field trip with some of my students. These are some architectural elements, people, sculptures and things from a place called The Bellevue in Philadelphia, which is basically a food court.

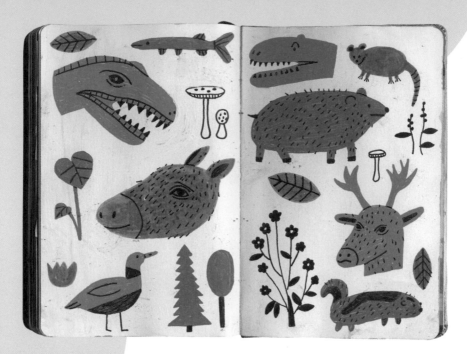

This sketchbook spread was done at The Academy of Natural Sciences in Philadelphia. I prepainted my Moleskine yellow and then used gel pen, marker, paint pen and ink to draw the animals and plants.

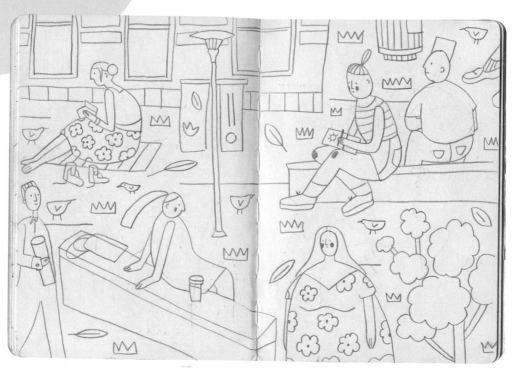

A quick pencil sketch from a park just outside of Philadelphia City Hall.

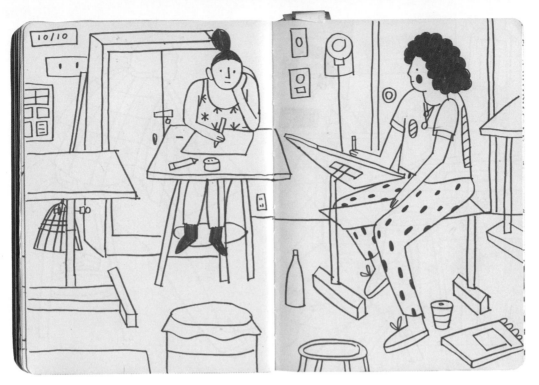

A marker sketch of students from when I was substitute teaching for a figure-drawing class.

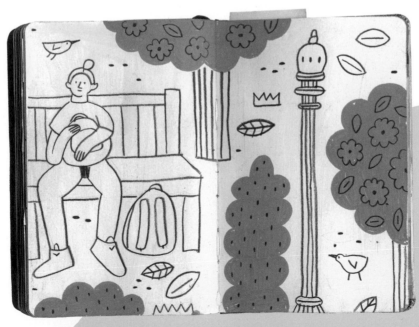

Another spread on the go in my Moleskine. This time, I was drawing at Rittenhouse Square park in Philadelphia. **Now it's your turn to draw on the go!**

Go to the park and draw! You can draw people, trees, benches, animals or anything else you see.

Draw in a cafe. Cafes are one of the best places for people-watching and drawing.

Take your sketchbook to a museum! You can draw people or be inspired by artwork.

Draw on a road trip, flight or train ride. You can draw people, snacks you are eating or road signs you are passing.

Draw every plant you own (or wish you owned).

Draw the view from the windows in your house. Include the window frames and any window treatments.

Draw your favourite object. I personally would have too hard of a time deciding between all of my knick-knacks, so you can also pick more than one thing.

Draw your pet. If you don't have one, you can draw your favourite animal.

Turn household objects into people.
Here's my one of my lamps turned into a lady!

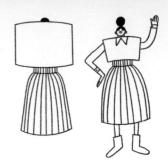

Recreate the characters from your favourite fairytale.

Draw a nurturing librarian.

Draw a bored teenager.

Create your own geometric pattern.

Create your own floral pattern.

Draw a bad hair day.

Visualise "love" without using the word.

Let's draw some flowers! If you like how these turn out, you can always make them into bigger patterns. First, let's draw a rose.

Now, try drawing a lily.

Next, a magnolia.

And finally, draw a poppy.

Draw 10 dogs.

Draw 10 cats.

Draw a portrait of a person in profile view.

Illustrate a person with pink hair.

Create a portrait of an elderly person.

Draw a person with giant glasses.

Draw a recent dream.

Illustrate an embarassing memory.

Draw the messiest room in your house.

Fill this spread with shoe drawings.

Fill these pages with drawings of your favourite snacks.

Create your dream garden.

Draw a summer scene. Is it a pool day, beach day or a day to garden?

Hand letter your favourite words.

Draw a happy memory.

Fill these pages with animals.

Draw what you did yesterday.

Illustrate your family.

Draw a group of people going to a fancy party. Go over the top with their outfits!

Illustrate a bad date.

Draw your favourite meal.

Fill these pages with people and portraits.

Draw a landscape with a medium that is new to you.

Draw a red carpet gown.

Illustrate your favourite animal in a limited colour palette.

Fill these pages with cars. I personally love drawing vintage, boxy cars.

Draw a spring scene. Don't forget the flowers!

Create your own children's book characters.

Draw a group of friends.

Illustrate a couple.

Draw a lady with big hair.

Illustrate someone wearing a bow tie and big hat.

Create your own town. Is it big or small?

Draw a portrait of your favourite person.

Draw where you live.

Draw a winter scene. Maybe it's a snow day?

Draw something inspired by a famous piece of art.

Draw something inspired by your favourite song.

Illustrate your favourite room.

Create your own characters. Write their name and personalities beside them.

Draw an armchair.

Draw a cottage. Maybe you can surround it with trees and flowers?

Create a repeat pattern inspired by the ocean.

Design your own bags.

Draw an autumn scene. This would be a great place to try out an analogous palette (page 230) with yellows, reds and oranges.

Draw a city skyline.

Last one! For this spread, I'd like for you to revisit your Fun Things to Draw List on page 216. Fit as many of those things on these pages. Happy drawing!

Welcome to the end of *Sketchbook Challenge***!**
Need some more ideas to keep you going? Here is a list of prompts and inspiration.

1. flowering trees
2. poodles
3. a large sunhat
4. poofy clothes
5. vintage cars
6. Victorian portraits
7. dancers
8. big hair
9. braids
10. pigs
11. leaves
12. moths
13. books
14. anything from the 70s
15. moustaches
16. berets
17. funny words
18. ponies
19. party hats
20. bows
21. pigeons
22. pigtails
23. teeth
24. giant glasses
25. a beer/bottle label
26. London
27. quilts
28. cottages
29. parrots
30. Russian architecture
31. doors
32. botancial illustration
33. trees
34. a giant sundae
35. vintage matchbooks
36. fuzzy coats
37. pies
38. Victorian houses
39. Pyrex dishes
40. Amsterdam
41. maps
42. maximalist rooms
43. mid-century art
44. sewing patterns (great for poses)
45. makeup
46. pottery
47. old advertisements
48. Baroque hair
49. folk art
50. vintage tiled bathrooms

Bye for Now!

Congratulations on completing your *Sketchbook Challenge*! Sketchbooks are my favourite thing in the world, and I hope that this book fueled your future sketchbooking adventures. It's so important to keep in mind that no mistakes can happen in your sketchboook. Continue to experiment, create, make things you enjoy doing, and most importantly, keep drawing!

Remember to share your creations on social media with the hashtag **#SketchbookChallengebook**.

Acknowledgments

I am so thankful to have been able to write and illustrate this book about one of my greatest passions. It wouldn't have been possible without my wonderful editor, Kate Pollard.

I want to give a special thank you to my lovely and supportive partner, Matt. He has been there through all of my freelance struggles and successes. He is truly the best.

I also want to extend many thanks to my family and friends. A special acknowledgement to my parents, who have always encouraged my love for art.

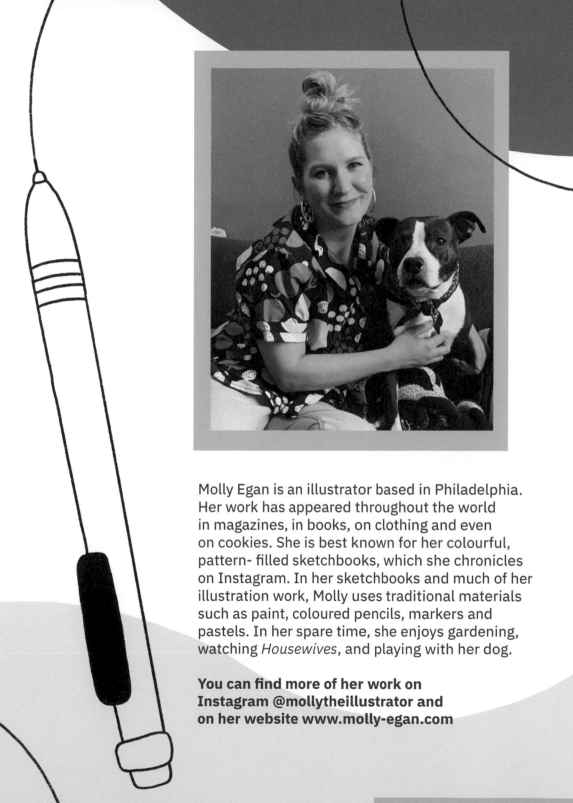

Molly Egan is an illustrator based in Philadelphia. Her work has appeared throughout the world in magazines, in books, on clothing and even on cookies. She is best known for her colourful, pattern- filled sketchbooks, which she chronicles on Instagram. In her sketchbooks and much of her illustration work, Molly uses traditional materials such as paint, coloured pencils, markers and pastels. In her spare time, she enjoys gardening, watching *Housewives*, and playing with her dog.

You can find more of her work on Instagram @mollytheillustrator and on her website www.molly-egan.com

Published by OH Editions
20 Mortimer Street
London W1T 3JW

Design © 2021 OH Editions

ISBN 978-1-914317-04-0

Text and illustrations © Molly Egan
Photograph on page 222 © iStock.com/max-kegfire
Production: Rachel Burgess

A CIP catalogue record for this book is available
from the British Library

Printed and bound in China.

10 9 8 7 6 5 4 3 2 1